Dearest Caitlin,

May your heart Sing
with the music
of the Spheres

With Love,
Dr. Bob

Visions of Thought

A collection of inspirational imagery and poetry

Robert Sasson, M.D.

AuthorHouse™
1663 Liberty Drive, Suite 200
Bloomington, IN 47403
www.authorhouse.com
Phone: 1-800-839-8640

First published by AuthorHouse 8/13/2008

ISBN: 978-1-4343-8356-3 (sc)

Printed in Korea

This book is printed on acid-free paper.

authorHOUSE®

Visions of Thought

Is dedicated to my family in Spirit

Elie Sasson, my father

Who inspired me to conduct my life
With a dedication to excellence
In all of my pursuits

Sarah Sasson, my mother

Who nurtured me
With the comfort
Of her culinary delights

Sam Sasson, my brother

Whose life in this Earthly realm,
Although way too short,
Was an inspiration to all
Whose lives he touched
His words and actions
Taught me to see the beauty
Of the world surrounding me

And to my blessed family, friends, and patients
Whose presence in my life
Serve as daily reminders
To live in the precious present
And live every day

As though it were my last

Acknowledgments

My deepest gratitude and love
To my Spirit Guides
Who've brought the messages
That I share with you

My humble thanks as well
To the Angels who've always been there
To guide, sustain, and comfort me
In good times as well as challenging times

Special thanks to Susan Apollon,
Mary Ellen Winn, Dr.Beth DuPree, Yanni Maniates,
Dr. Jill Samo, Corry Roach, Heather O'Hara, and John Harricharan
For their words of encouragement and support

And to
Omar Hameed, graphic designer and gifted artist
Who intuitively grasped my vision
And through his technical wizardry
Assisted me in the cover design

And to
To the staff, patients, and families of
Kids First-Newtown
Who continue to show me daily
New ways to love and support them

And finally
To my family and friends
Who through their unconditional Love
Aid me on my personal journey

On the path to healing and Love

Foreword

Life is a journey, and, as with any journey, there are going to be opportunities to meet and connect with souls who will have extraordinary impacts on our lives. You are about to meet one such soul, Bob Sasson, a healer, not only of the body, but also of the soul.

"Dr. Bob," as he is sometimes called by his young patients, is a gentle, wise, compassionate individual, who is loved by children, admired by adults, is a role model for parents, physicians, educators, and in fact, for all of us. A being of great sensitivity and of heightened spiritual awareness, he lives his life with a vision of the goodness that lies within each human being.

Rarely are we privileged to meet someone who is gifted on so many levels. Within his chosen profession of pediatric medicine, Bob lovingly soothes, comforts and heals his patients. Children are drawn to Bob as they might be to a "pied piper." Perhaps, this is because they know he is aware of their innate goodness, decency and the loving heart with which they -and all of us -were born. Perhaps it is because he is able to make each of his patients feel extremely valued, honored and special. It may also be because he truly listens to them, their feelings and their thoughts, enabling them to feel genuinely safe, and unconditionally accepted in his presence.

Yet, Bob is able to extend his healing capacity beyond children, beyond the physical, to the soul. It is not often that we find such sensitivity and understanding in one who already heals the body, and who can then apply these gifts to an artistry which genuinely connects with our higher aesthetic senses, as well as our inherent intuition regarding what feels comfortable, familiar and truthful for us.

Bob has the uncanny ability to capture a scene, a landscape, an animal or a person in the throes of great emotion which touches us at the deepest level of our being, because, we, too, have at some time felt what he feels, and we, too, can identify with his experience. His writing and images mirror the Truth and Beauty of our existence and our journey. Indeed, this is his power.
The poems you are about to read represent the natural, easy flow of loving thoughts which divine energy has channeled into the heart and mind of Bob Sasson. His words are written with such a sense of intuitive knowing, as well as warmth, intimacy and love, that you may wonder if it is Bob who has actually lived the lives of his characters.

For more than thirty years, I have treasured the gift of my friendship with Bob. During this time, I have observed Bob heal by empowering, providing comfort, offering hope, addressing our spiritual roots and connections with our angels and Spirit, and, most important, by helping us to remember our genuine and authentic loving nature. His kind, gentle manner aligns with our inherent goodness and reminds us that we are, at our core, beings of Love and Light.

Be prepared to be inspired, touched at the level of your heart, and reminded of your magnificent and eternal essence, which transcends everything you experience during this lifetime. Enjoy!

Susan Barbara Apollon, Psychologist and Author
Touched by the Extraordinary: An Intuitive Psychologist Shares True Stories of Spirit and Love to Transform and Heal the Soul (CDs and book)
www.touchedbytheextraordinary.com
Intuition is Easy and Fun: The Art and Practice of Developing Your Natural Born Gift of Intuition (CDs and book by Yanni Maniates and Susan Apollon)
www.intuitioniseasyandfun.com

Introduction

As just another Soul traveler spending some time on Planet Earth, I have come to a point of contemplative reflection on our purpose here. In the short span of nearly sixty years, I sometimes feel like I am in a time warp. The growth of human Consciousness has birthed ideas and materialized wondrous inventions, one could only dream of just a short time ago.

In the last century alone, humankind has witnessed remarkable advances such as the telephone, television, and computer. Our interconnectedness has become facilitated by the expansive growth in knowledge, and the rapid dissemination of information through tools like the Internet. The birthing of new ideas and the expansion of Consciousness have given each of us a seemingly limitless choice of options. We can so easily be led by the tantalizing presentations that besiege us in the various media, and get lost on our journey, losing focus, clouding our vision of our purpose here.

The words and images presented herein have been given to me to share with you, the reader, as a gift from my Spirit guides. There is much recent literature, which bears testimony to Angelic forces enabling us and guiding us on a path toward Enlightenment. The Universal force field has its own unique wisdom, using the tools of Light and Love to counter the disruptive and destructive effects of man's inhumanity to man, and the desecration and denudation of our Earthly realm.

The birthing of this book took seed in the spring of 2007 when a dear and wise friend, in fact an angelic presence in my life, Susan Apollon, told me about an upcoming event called *The Power of Spirituality*. Susan informed me that I "was supposed to" attend this program being led by a very special and spiritual man, John Harricharan.

A group of thirty-five from all over the globe met in Atlanta for a weekend in May. We came from all walks of Life and quickly bonded as a group. It was there that I met an extraordinarily talented and gifted woman, Heather O'Hara, who shared with me a book of poetry she had published, *Axis-The Song in the Center of the Soul*. Her words profoundly touched me. After inquiring about collaborating on a book, coupling her poetry with my artwork, she responded with the recommendation that I give thought to writing my own poems. I had not written a poem in forty years. With these words of encouragement I was inspired to write my first poem, *Just a Glimpse*, on the plane trip home.

It soon became apparent to me that I was being used as a vehicle to bring messages of hope, inspiration, and guidance to my fellow Earth travelers. Strong visual images came to me, often awakening me from a deep sleep. In a state of meditation and focused consciousness, I used mind to bring words to the pages of this book. The opening poem, *Visions of Thought* serves as a gateway for the reader's unique voyage toward the growth of Consciousness. Embrace Life with passion, and see each challenge as an opportunity for growth.

With Love and Blessings to my fellow Soul travelers,

Robert Sasson, M.D.

Contents

Contents

Visions of Thought

Visions of thought awaken me
My Soul journeys in my deep slumber
To a special place
Where I can remember who I AM

The heavens have opened up their Love to me
Lifting my earthly presence
By an ethereal string
To a higher vibration
Of Love and Light

This Divine power
Embraces my Soul

The infusion of Love
Like a heavenly cocktail
Intoxicates me
With the Joy and Wonder of a child

Expanding my Consciousness

The merging of Vision and words
In a celestial orchestration
Enabling my humble presence
To be an instrument
Of Divine healing

I pray that these messages
Lift you from your deepest sorrows
Hurts and fears
Acquired along life's sometimes painful journey
And take you to a place of comfort and joy

Seek out your highest Wisdom
And know
That your essence is pure Love

May you find Beauty
In all of life's moments

May your Spirit
Rise with each breath
Of the Universe

May your Heart sing
With the music of the Spheres

May you dance
Like the sparkle
Of the Sun
On the morning tide

May you end each day
With a restful sleep

Yet... while you sleep
May your Soul
Commune with the Angels

It is with the deepest gratitude and Love
That I share with you my

Visions of Thought

Bubbles

In a grand gesture
Her wand sweeps a wide arc across the azure sky
Little bubbles fill the air around her
A holographic display of Light and Beauty
God's reflection of her essence in each rainbow
A beatific smile
Casting her energy of Love
Out from this bundle of Sunshine

She knows not of fear, insecurity, or judgment
Her giggle is the pure vibration of Love

She dwells not in the fading accomplishments of yesterday
Or the anticipated successes of tomorrow

Her joyful presence seeks not to own, or control,
Or seek power at another's expense

She lives not in fear of having enough,
Or doing enough, or being enough

She has only Now
Living in harmony
With the babbling brook
The birds in flight
The restless surf
Crashing incessantly on the shore

Seek out your child within
Your ever-present reminder of who you are

Capture your Dream
Pursue your Vision
For in that communion of Soul and Spirit
Your true Self will be found

The Cauldron of Life

The cauldron of Life
It's all in the stew
The beggars, the braggarts
The beauty, the blues

Wildflowers, weeds, and wisteria too
In the whimsy of the winds they move with grace
Lilacs and lilies, lavender, and lace

Your baby, soon toddler, the first day of school
A kiss and a hug, a shedding of tears
As she gets on the bus

The years move so quickly
Your time here is short
Savor every moment and the lives that you touch
There's no such thing as loving too much

Your daughter stands tall
A woman she's become
The lust of lovers
Stargazing, picnics, the summer they shared
The beach, the beer, the dance at the pier
The kiss of their lips
A caress from the heavens

The walk down the aisle
The veil is lifted
The joy of the bride
Your heart fills with pride

Memories recaptured
The scents and the sounds
The sights seem so fresh
As though time has stood still

Laugh often, and loud
Wear a smile and be proud
Dance and sing like the bird on the wing
Enjoy the fashions
Live life with passion

We're all in the cauldron
This place we call Earth
May your heart overflow
With Love and with Mirth

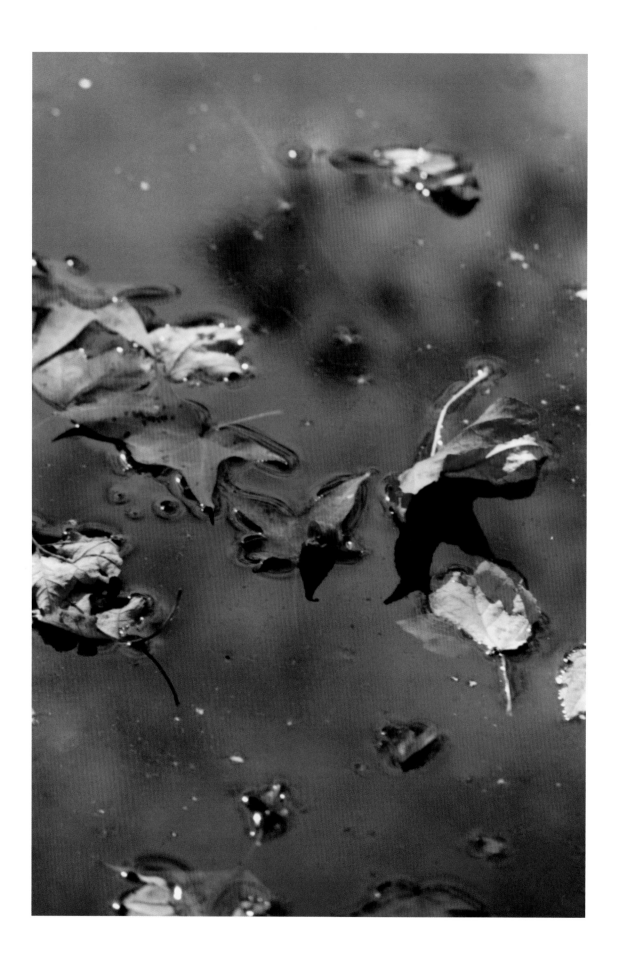

Light and Leaves

God's light shines through…
The branches and leaves extending like wings

Reflections on still water
The curling leaves…their lives now have passed
Yet dwell on the surface
Basking in the sun
In their twilight days
They speak to us of Love
And of God's joyful ways

Our passage is short
We've been here before
Our Soul's many journeys
To these time honored shores

We are the Light, and we are the Leaves

And as the leaves start each year anew
Our lives are reborn
With each passing view

We are more than ourselves
We are Beings of Light
We are the Sun and we are the stars
We shine like a diamond
Like a moonbeam on snow
On a clear winter's night

A Morning Prayer

As I awaken the arrival of a new day
A prayer of intention and peaceful presence
Open my heart to infinite possibilities
Reconnection to Source
The dissolution of Ego boundaries
The Universal force field
Manifesting itself
Through words and visions
To be shared and spread to my fellow Souls
Vibrating harmoniously
In their search for meaning

Our bodies, with their physical needs
May…at times
Appear to be in conflict
With the journey of the Soul traveler
These bodily needs knock on the door
With incessant demands
For our attention
Mired in its earthly presence
I'm hungry, tired, hot, cold, the season's new fashions,
A project due at work,
The promise of a new relationship
A seemingly endless parade of needs
Asserting themselves
In no particular order of importance
Enslave us, consume us, direct us
With their pleas for attention

A prayer to your Spirit guide
A deep slow breath
Bring you back to who you are

Each action of your day
Imbued with thoughts
Of Love and Compassion

Reminders of your purpose here
To dissolve the fears and bring Joy
To those who surround you
Each moment a blessing
A special gift from the Universe

Let your mind be filled with the thoughts of
Dewdrops on the petals of a Peony
The amber skies of a beautiful sunset
The morning call of a songbird
The scent of Lilacs sharing their bounty

All reminders of our shared Divinity

The Plea

The wind sweeps across the prairie
A veil of dust blankets the parched earth

A dull yet steady ache
Accompanies her as a constant companion
Fingers raw from picking her meager crop

Deep furrows on her weather beaten face
Bear testimony to her challenged existence

Hungry faces are daily reminders
Husband off to war
Fields to plow, seeds to sow
Even the horses are gone

The dry soil sifts through her fingers
Like the sand in an hourglass

She kneels
Knees aching as she does so
Eyes that cried so freely
Hardly able to shed a tear

An anguished plea to the Universe for help

How will I feed my children?

A tear drops down from her cheek
Another…and yet another
Yet no!
Her eyes gaze up
A crack of thunder

The heavens open and pour their
Blessings down upon her

Peek Through the Curtain

From the edge of awareness
My thoughts wander
They speak to me at once
Of pleasure and pain
And play in the field of pluripotentiality

Free from my body
Amorphous thoughts…plentiful
Abounding with possibilities
Expand in waves of consciousness
Too great for one small facet of Spirit to describe

Pulses of energy arise from the wellspring of Source
Appearing first as thought forms
The creation of images
Nebulous at first
Alas channel down
To connect with the landscape of Mind
Manifesting the visions
Of our planetary domain

Ego versus Spirit
The tug of war of the Ages
A paradox it might seem
The Time-Space continuum
Allows all entrants
Who can peek through the curtain of Life

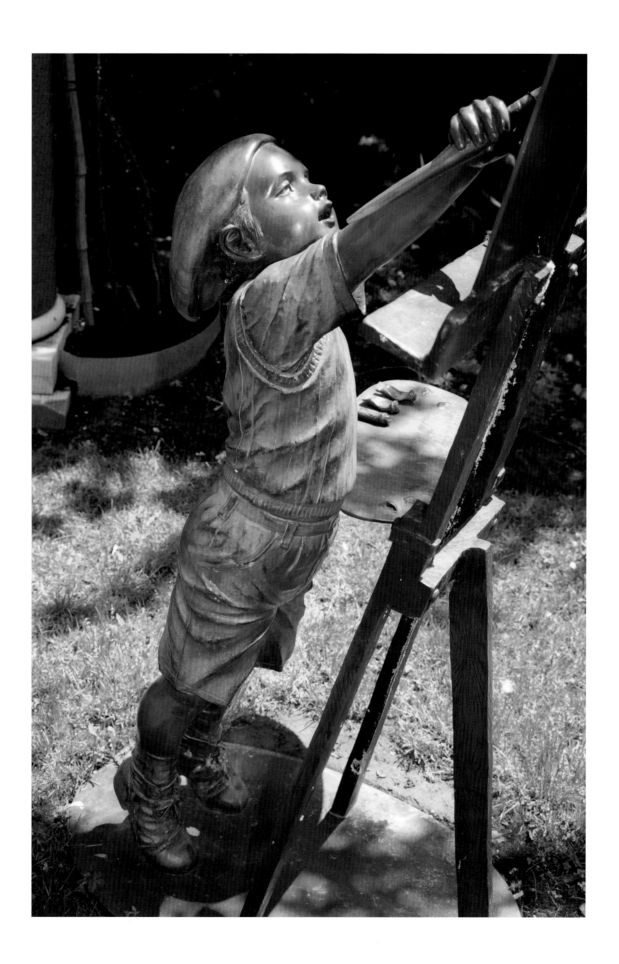

The Painter

Standing erect…high up on his toes
Outstretched arm…brush in hand
Artist's beret to inspire this lad

Today he will paint his masterpiece
Will he paint from life experience?
Or visions residing somewhere in his unforeseen future

Thoughts stream through his never still mind
His third birthday party…what a special time it was
The excitement of riding his first two-wheeler
The first day of kindergarten
Carrying his new shiny lunchbox
Inside… his favorite sandwich…peanut butter and jelly

His mind shifts…a glimpse of his future
His bride to be
A vision of radiant beauty
Her exquisite dress
Following closely the boundaries of her body
Hugging her tightly like a mother's embrace
Her Love and presence cementing their Souls
Linked in an eternal bond
Destined to dance together in the sands of time

The brush touches the canvas
The paint disbursed in a splash of color

A call from his mother

"Lunch is ready"

Joy

Joy is a crocus
Rising up through the last snow of the season
Tulips dancing
As they sway in the breeze of a crisp spring morning
Buttercups in an Alpine meadow
The laughter of a Sunflower
As it turns in the course of the day

A child blowing bubbles through a straw
The slurp of the last sip of a milk shake
The giggles of children at play
A special hug at the end of the day

The crunch of the first chip
From a freshly opened package

The scent of a sizzling steak on the barbecue
A swig of a cold beer at the end of the day

The fragrance of roses as you enter the garden
Dressing up in your finest clothes
For a special night out
Holding hands as you walk in the park

Listening to Frank Sinatra singing My Way
A Cole Porter show tune
An Andrew Lloyd Weber musical

Enjoy these blessings and gifts from the Universe
Savor these moments
They are always just a thought away

Quantum Leap

Her pen moves nimbly across the page
Generating the words of new tomorrows

In this earthly presence
Her essence seeks only
The successful transit of Souls
That shuttle back and forth to Earth
Through the eons of time

Time…a grand illusion
A magician's tool
Created purely for the processing of experience
On this planetary realm

The words are scribed
Guided by an invisible force
With a spiritual transcendence
Yielding a short lived glimpse
Of the perceived visions
Of another reality
Free of the prison of the senses

Consciousness raised…the transit
To a world of peace and harmony
Existing at last
For the sole purpose
Of the co-creation of Divine perfection

Where Love chases down Fear
And melts it away

Where self knows only Self

Where the illusion of duality
Gives way to the spark of Divinity

Where Time dissolves
In the wake of Infinity

Passages

I rise through the strata of Consciousness
A slow yet confident ascent
Through the channels of Wisdom

Energy expanding
Taking form
The helical pattern
The nautilus, flowers
Each manifesting in accordance with natural law
As described by Fibonacci
Centuries ago

Omnipresent clues surround us
The graphic display
Of God's grand scheme

Each Soul like a petal
On a Divine flower
Growing… ascending
Reaching for the Light
The incessant movement of Souls
Toward the realization of Spirit

Building Castles

Carrying his new pail and shovel
He walks proudly along the shore
Kneeling closely to the water's edge

The surf breaks in a gentle rhythm
Like his mother's lullaby

Today he will build his castle in the sand
What knows he of foundations, walls, and roofs

His energy and innocence will carry him through
The patient loving and guidance of his caretakers
Imbue him with a strong feeling of confidence
A can do mindset

A mighty wave topples his creation
Patiently he toils
Undeterred, he recreates his Vision

How oft we surrender our Vision

It's too difficult
I can't do that
I'm not smart enough…or talented enough

Reach deep within
Remember the little engine

"I think I can"

Pawnbroker

Head bent down, scarf wrapped tightly
Knotted beneath her crumpled chin
Her arthritic hands
Struggling with the door knob

A little push
At last the door opens

Entering the pawnshop
Her eyes roam
The dusty glass shelves
Capturing objects
Once worn or shown handsomely
In polished glass cabinets
Of the privileged

Symbols of the evanescent status
Now gone from their graces
The music box
A string of pearls
A delicate diamond covered wristwatch
Her wedding ring
Pawned so many years ago

A time of hunger
And tattered clothing

Her last visit here
During her youthful years

So many years gone by

Her husband
Perished decades ago during the Great Depression
Three young children
No one to provide for them

Her hands now weak, knobby
From years of scrubbing floors
Her back hunched forward
A consequence of the endless hours
Of bending over a sewing machine
The stagnant, hot factory air
Filled with the humming of the machines

All in the past
Children now grown

Saving, thrifty, destitute for so long
She has survived and endured
Depriving herself through the decades
Unable to treat herself to a better life

Now she returns
To recapture her belongings
An attempt to reassemble
A life gone astray

Her cadence is slow
The journey to the counter
Only a few steps away
Wearily accomplished

The young man looks up
Taken aback for a fleeting moment

She speaks softly
Her voice barely audible
May I speak with Mr. Percy?
I would like to buy back my wedding ring
She retrieves a small piece of paper
From her well worn purse
And hands it over to the young man
The paper, weathered,yellowed
The print barely readable
The handwriting that of his grandfather
Scrawled at the bottom
Reginald Percy
October 7, 1933

He excuses himself
Minutes go by as he searches
The caverns of the shop
And at last locates
The hidden cache
Of her belongings

With a satisfied smile
He turns and walks back
To the front of the shop

The young man extends his hand
To this dear old woman
And hands her a small brown bag

Slowly she reaches in
Her fingers reacquainting themselves
With these lost pieces of her past

She looks up to meet his gaze
From the corner of her eye
A tear journeys down her cheek

Followed by a smile

A Precious Moment

The brush flows smoothly through his silvery gray hair

Her dimpled countenance
Observed from across the Ice Cream Parlor
Wiping the cool cream from her sweet, parted lips

She smiles fleetingly as their eyes meet
Yet she quickly turns back to her friends

What name belongs with this radiant presence?
Is she available?
Will she like me?
Will I risk rejection?

He looks back in the mirror
It seemed like only yesterday
Yet the feeling…. the anticipation…the excitement
Seem so fresh

He adjusts his bow tie
Straightens his collar
And smiles at himself in the mirror

Who could have thought?

She enters the room
He turns, their eyes meet
And with a big grin, he says

HAPPY 50TH ANNIVERSARY Sweetheart

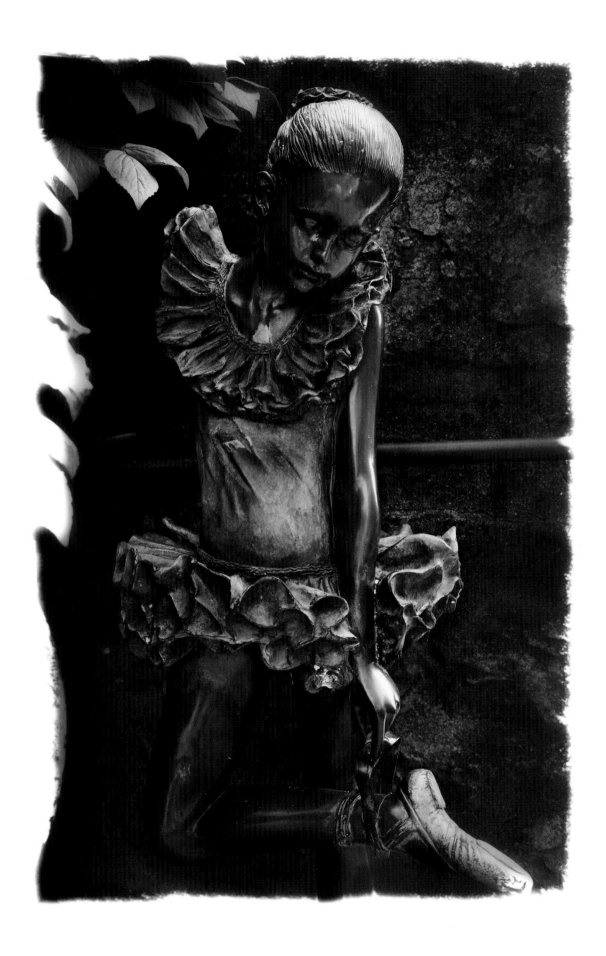

Ballerina

Movements filled with Grace
The steps so light
As though in flight

Focused, poised
The hands…the arms…the torso
Head uplifted
These strong legs
All finely tuned
Arching, swaying
An orchestration of cellular energy
Moving in a synchronous vibration of Life force

The discipline
The repetition of a thousand lessons
Bear fruit to this Angelic presence
Moving in harmony with the music
The melody encompassing her body and Soul
Lifting her to join with Spirit

A clap from the audience
Followed by others
Return her to her earthly embodiment

The glow of her aura radiating in waves of Joy

To the audience surrounding her

Let Your Light Grow

A Divine light flickers inside of me
As it does also with you

A daily reminder that
Love and Compassion
Hate and Strife
Are born of the same cloth

For the garments of Life
Vibrant as an elegant square of fine silk
Possess a lustrous side
Embellished in a tapestry of Love and Light
Reflective of our spiritual connection to the Universe

And in turn, there is a dark side
Too oft seen
Arising from fear and selfishness
Revealing the coarser aspects of mankind

Seek to purify your Heart
Let your light grow
From that of a meager candle
To a grand beacon
Lighting the way
For those gone astray

Your thoughts are wave forms
The energy of the spheres
They may be like arrows sent forth from the bow
Intended to harm
And sent with ill will

Send in their places
Your arrows of Love
Be bold and so daring
Cast off the shield
And armor your bearing

See the beauty of sharing
Your comfort and caring

Be like that light
Imbued with the Joy
That brightens the night

Your nature is Love
Your place to be joyful

Be like a dove
Bring Peace to your heart
The darkness will wither
The gloom will depart

Let your light grow
With the love seeds you sow

Gold Coin

Joy fills the moment
And a Blessing is born
Another coin tossed
In the well of unfulfilled wishes

The needy arise from amongst us
Threadbare collars
Rents in their garments
The testaments of grave conditions

Chapped, dry hands
Soiled fingernails
Fissures as deep
As their rivers of sorrow

Coarse, tousled, unkempt hair
Craves for the touch of a gentle brush

Hands of the supplicant
Create a bowl
Facing the heavens in despair

Order has no presence here
Chaos permeates the air
Like the stench of our unwashed brethren
Lacking the drops of water
To cleanse the skin
And purify their hearts

Go then
Reach deep within
Your silk lined pockets
Find the gold coin that gives
Your solace
A false sense of security
Bring it into the light
Where it can whirl in the wind

The Light of God
Noted in brief glittering reflections
As it spirals upward
Creating an arc of Love
An embrace for a troubled Soul
And with a din
Joins the other coins
In a Voice that rises to fill the void
Daring to reach out
To these impoverished Souls

Aiding, comforting, strengthening them
Rekindling their withered Spirits

The Train

Bent at the elbow
His arm extends above him
Holding the strap
Another part of a well-rehearsed daily ritual

A dull shrill as the train whistles through the tunnel
We're all in this together…this thing called Life

Blank faces stare ahead
Most appear dull…vacant

Two teens enter at the next station
Giggling, speaking out loud
The onlookers seem transparent to them
They talk of Love…summer plans
Dreams of their futures
So much ahead of them

Their words echo through the subway car
Each passenger receiving them
Reverberating through their Souls
Touching each right down to his core

A woman sitting nearby
Recaptures a moment like this so long ago
Her journey of self-discovery
What goals, dreams, passions to pursue?
Barnard College…Harvard Law
Her years as a law clerk
Now a judge sitting on the bench
Of the State Supreme Court

Retirement is drawing near
Her worth is wrapped up in her titles
Soon she'll step down
What will become of her?

There, in the corner
Newspaper tucked under his arm
A nattily attired
Well-groomed, elderly gentleman
A fixture on this train for decades
Clinging always to the familiar
His daily commute to Wall Street for over fifty years
What else does he know?
Where else can he go?

The art student stands
Arm wrapped around a pole
Each day bearing a large black leather case
Welcoming the stares

The curious ones
Always wondering about the contents
Perhaps his Vision can release their strangled minds
Minds so long ago disillusioned
Their powers so easily stripped away
Through the forces of fear and disapproval

Things don't just happen to us
We don't need to be the passenger
We can choose to be the driver

What choices will you make?

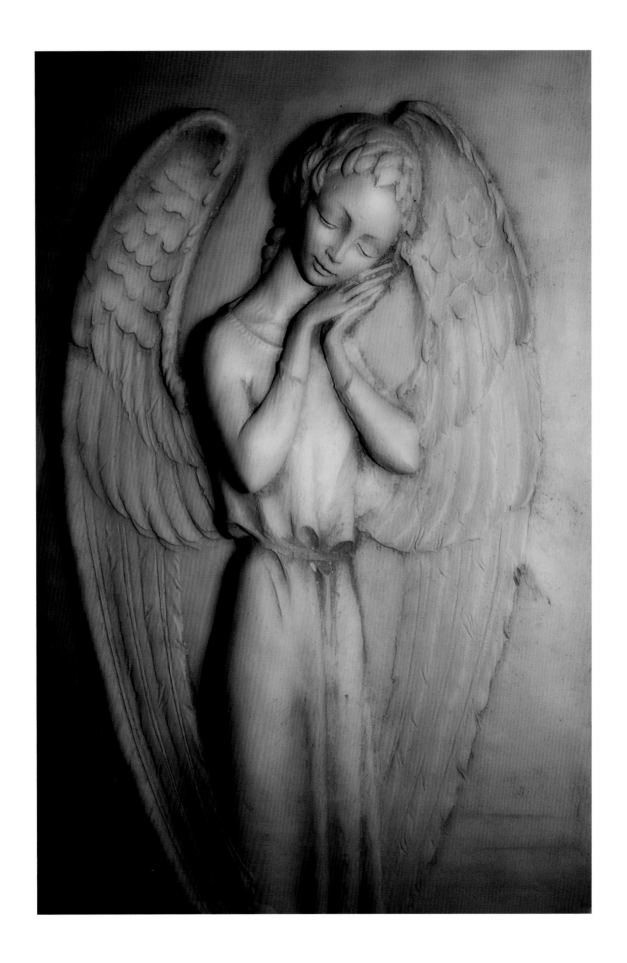

My Special Angel

The Angel stands
So delicate yet so powerful
Hands clasped
Head resting ever so gently upon them
Eyes nearly closed
Deep in prayer

Wings to carry her
Wherever there is need
Feet to aid her on earthly journeys

She dwells outside and also within
Her beauty transcendent

Her Divine presence warms our hearts
And also melts our fears

Her essence so serene
Always present…always with Love

She'll guide us through our troubles
And help us rise above

Trying Times

She sits...open book in hand
She tries...yet can hardly remember the words
Read just only a moment before
Her thoughts racing
Endless mind chatter
Circling, repeating

She weeps
An ocean of sadness
Tears...shower down her face
Mirroring the raindrops of the Mother
A vain attempt to ease her pain

A sigh
A searing pain echoes forth
From the aching of her soul
This deep hurt shared with her countless sisters

Life.. a collage of sounds, images, thoughts, experiences
Parade before her
Choices made
Power depleted day by day
In waves of self sacrifice
Eroding, weakening
Washing away her strength, self confidence
Dreams and visions, once palpable
Pass like distant clouds

Life...so different only a day before
Past concerns seem so unimportant now
Appearing so petty, so minor

She sits... gripped by fear
Out of control...like the cells deep within her breast

She took pride in being in control
What is control anyway?

Is it not an illusion to think you can do it all?

Love unlocks the shackles of fear
Yielding a new sense of Being
An awareness of your higher purpose
A raised consciousness
Lifting your Soul
From the depths of depression
Hope rises up to strengthen and comfort you

Help, guidance, healing are close by

The Search

The oars slice gently through the still waters
Shards of sunlight seek their way through the canopy above
Parcels of light descend
A myriad number of fragment images
Wax and wane as ripples of water
Radiate from the bow

The large brimmed brown canvas hat
Lay askew on his tall frame
An arm raises up as he wipes
The beads of moisture from his sweaty brow

Uncharted territory
Alone yet not lonely

Fear peaks through
Yet is quickly neutralized
As once again
He feels the oneness with his surroundings

Life passing with the gentle breath of the creek
Embracing his vessel
Shepherding him on this journey of discovery

As he seeks beyond
He must also seek within
The inner realm always present
Just beneath the surface
Waiting to be revealed
And realized
To its greatest potential

The spiritual elixir of a Soul in flight
Searching at last for Home

A Miracle of Grace

A miracle of Grace passed my way today
I beheld an Angel
Whose golden wing was frayed
Her grimace revealed the pain she faced
As she ambled through the galaxy
Uncertain of her crippled fate

I turned within and beckoned
My fellow Soul travelers
To unite in prayer
For this Angel so dear
We grounded and centered, and shielded our Souls
To protect us from the field that created this tear
To the Universe we sent forth
Rays of healing
Arrows of Love
To mend the wing
Of this messenger of God

Our prayers were pure, untainted by self
We visioned the Light
Sewing the rent of this heavenly sight
With a golden thread of Love
The power of Love we witnessed that night

The Angel looked back
A beacon of Light
Her grimace transformed
Her glow, her energy
Her beauty restored
Her Love and her Joy
She sent forth in return
Our Souls reverberating with this Divine presence

Awakened from our trance
The morning light danced
As the Angel flew away in the eastern sky

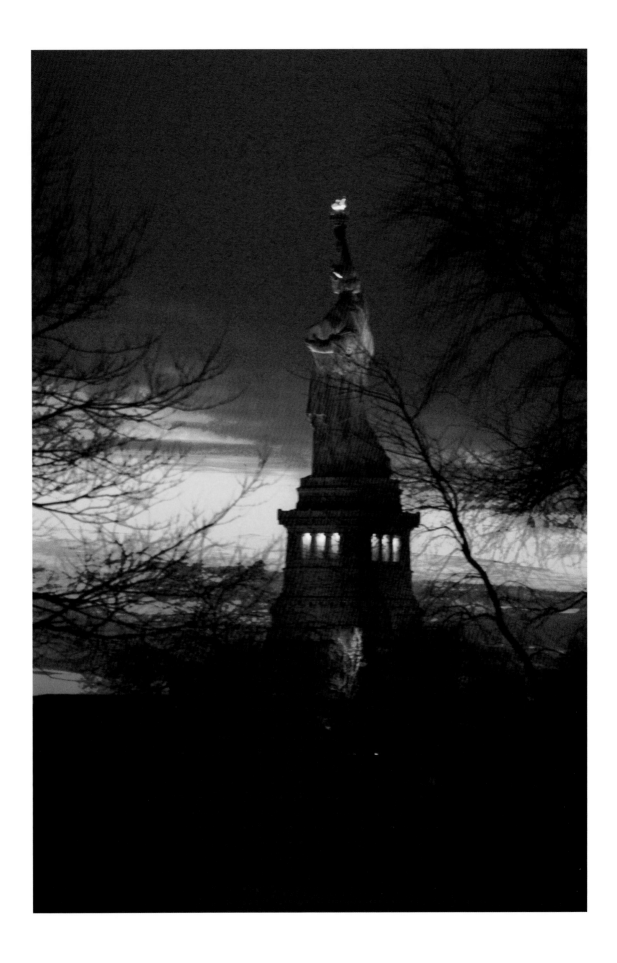

Light in the Harbor

A firm pull followed by a sigh
A wipe of her brow with a sweat soaked kerchief
The heavy trunk advances slowly
Tired feet, worn out shoes, aching back
She ascends the metal steps
Emerging from the deep recesses
Of the large vessel

Waves of hunger and loose clothing
Constant reminders
Of the meager rations offered
Only mere months but seemingly years
Tossed about in turbulent seas
Tight, cramped quarters
Shared by thousands
In the ship's hold

Although weakened by life's travails
They have endured
Many a sacrifice made
For the promise of a new tomorrow

Arriving at the top of the stairwell
The cold air floods her being
With its bitter chill

Family memories fill her mind
As she wraps herself tightly
With the hand sewn quilt
Painstakingly crafted
By her grandmother for her passage

The tears, the farewells and goodbyes
Family, friends, well-wishers
Never to be seen again
A transient moment of homesickness

Footsteps multiply
The quiet chatter of those below
Gives way to the boisterous dialogue
Of those now on deck

The large ship glides slowly upstream
Against the gentle current of the bay
Distant lights flicker in the dark night

A Vision once only a dream
Dares to become a reality

Alas they see her majesty
Pinpoint at first
Her countenance soon envisaged

A beacon of light
Watching vigilantly over the harbor
Like the colossus of ancient times

Jubilance and tears pour forth
As they look up at
Our Lady of Liberty
Bearing her raised torch

The humble beginnings
Of the Promised Land
Their prayers have been answered

The Writing on the Wall

Crouched in the cave
Shadows on the rough hewn rocks
Dance with the flickering light of the flame

Stones crushed and beaten
Mixed with clay
The forebears of paint
Ochre hues slowly take form

Images appear
Primitive chronicles of man's earliest journals
Bearing witness
To his presence here

The messages are timeless
Man's continuing efforts
To understand his place in the Cosmos

What did he know of Life and Love?

Are we any closer than he?

A Moment of Truth

Capriciously scurrying along
Rambling through her day
Filling her arms, eyes, ears, and more
With the sensual enticements of her surroundings
Exploring her world through her senses

Is that all there is?
Never satisfied except for a fleeting moment
Seeking fulfillment
Yet not knowing where to turn
How can one comfort others
When so much discomfort lies within?

The path to healing
Starts with a pause
Seek the space between the words
Between the thoughts

Stop to listen
To the music in your heart
Ride the wave of the Universal energy
Relinquish your attachment to things

The Dance of Love

Love seeks its own path
Sometimes harmoniously…often discordant
A cacophony akin to one's first recital

The dance of Love is awkward at first
Each stepping on each other's feet
Moving to one's own beat

When we dance alone
We know not of accommodation
And give and take

It is only through relationship
That we can learn to Tango with our partner
Leader or follower?
Will you follow the known steps and take a safe path
Or step forward fearlessly in God's great arena
Creating your own dance?

It is through the practice and honoring
Of one another's footsteps
Blurring the boundaries of your egos
That you can dance together
To the music of the Universe

The Sparrow

A sparrow landed on a branch
One cold barren winter morning

Hunger spoke to him
Exhaustion set in
His energy consumed
In a futile search for his daily sustenance

Grounded in fear
Possessed by thoughts that his life
Would soon draw to a close
He wept
His tears flowing
Like a river of sadness
Weak…his eyes nearly closed
His body preparing for
It's journey to the afterlife

From the corner of his eye
He sees a door open
A frail, old woman emerges
From the warmth and comfort of her home
A small bag appears
She replenishes the empty bird feeder

A reminder to us all of the impact
Of a small act of kindness

Currents

The current swirls through the rocks
The tide ebbs and flows
Pulsating with the rhythm of Nature's breath
The rough hewn stones
Their surfaces smoothed with the gentle kisses
Of Earth's fluid energy
The caresses of the millennia

Small schools of fish
Sway to and fro
In harmony with the eddies
Of the tidewater pools
Embraced by the rocks
Which encircle them

Lovers bound together
Their reflection in the water
Life's cherished moments
Their swirl of energy
Mirrored in the water below

On the Road

The massive, centuries old, time worn door
Creaks slowly open
A pale thin teen emerges from within
Cap…slightly askew
Satchel slung over his shoulder
Wrinkled tunic draped loosely over high waisted shorts
Well-trod sandals cling closely to his feet
Like dedicated friends

A tear drips down as he turns his back
One last glance
Memories flood his being
A maelstrom of emotions

Left behind…Comfort…Familiarity…Security
Ahead…Doubt, Fear, Uncertainty

The path unfolds
The dream begins
The clouds of doubt
Fade away with the strength of self-confidence

Embrace uncertainty
That is all that we have

Only boundless thinking can lead to a limitless vision

Follow the vision

My Heart Reaches Out

Love echoes forth
Like a whisper through the Galaxy
My heart reaches out
For a Love
That I know that can be
Struggling to grasp that place
Where true Love can soar

Crippled by a past lacking the rubric for a firm footing
Like flotsam on a turbulent sea

This Soul, seemingly lost
Is all but that
Spirit Guides have facilitated the journey
Of this weathered veteran of the Universe
To learn Life lessons through accelerated karma

Some will take an easier path
And learn at a more modest rate
Here in Earth school

It is only through the trials of Life
And serial experience
That a steadfast Love can endure

For all encompassing Love
Is far more than words can describe
Never to be fully expressed
While man resides in the physical plane

The Hourglass

Sand falls through the hourglass
Marking time by its passage

A moment, a day
The years pass fleetingly

The smooth, soft baby skin
Gives rise to the coarse stubble of manhood
Alas the furrows and craggy landscape make
Their appearance on the stage of life
Mirroring the mindscape of the soul's journey

The path
The notable first steps
An indelible marker of life's milestones
Soon to give way
Like worn out macadam

Moving inexorably forward
Trampling the flowers
Too focused to care
Places to go!
Things to get done!

Just what will you do
When you do get there?

Riding the Rails

The burlap bag lies beside him
The crumpled visage of this man lost in time
He sleeps soundly
Lulled by the clickety-clack
Of the rails beneath him

Passing through towns
Crossing this great land

He is now without roots
Meager rations sustain him

Pitied by those he encounters
Stripped down to this humbled state
Carrying only a few memories and
Bare essentials in his weathered satchel

His three piece suit and derby
Remnants of his once renowned status
Are bittersweet memories

The success could be intoxicating at times
The mansion, the grounds, the flower gardens

But… there were pressures then… responsibilities
Keeping the factory running
The troubled faces of the hungry men
Arriving daily at the gates seeking a day's wage

And yet… his poverty has now freed him

Unfettered by possessions
He dreams his way through the passing landscape
Little notes and drawings
Whirl through his subconscious

Visions of parts crystallize in his mind
A new invention
Ah…this will change the world!

The brakes squeal as the train
Arrives at its destination
The shrill sound awakening him from his deep slumber
The vision of this dream remembered
In all its extraordinary details

A big smile crosses his face
His journey of despair will soon come to an end

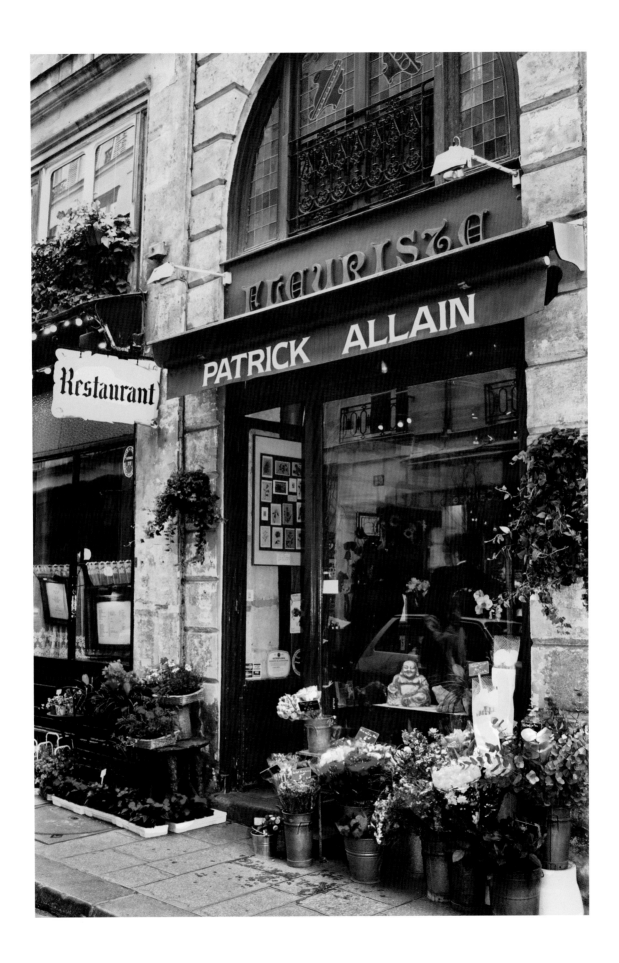

Patrick Allain

With a click the door opens
The lights are turned on
The tall stainless steel containers
Are filled with fresh water
Brightly colored flowers
All shapes and sizes
Placed ever so carefully
Give life to these vessels

Arranged at the storefront
Their beauty alluring
The scent of the flowers
So sweet and enduring

They beckon and call
And beseech us to stop
And enter the portals
Of Allain's flower shop

We all seek out beauty
On our way to and fro
The banker's wife …some roses in tow
A dinner tonight…a special occasion
Her home will sure glow
With these roses you know

The dancer steps in…the daisies she sees
To cheer her today…as she goes on her way
For tonight's her last show

Inside there is fear
A prayer she will say
For a job to appear
Her legs are so weary
The dancing is hard
She opens the mail
And smiles at the card
Today is her birthday
And someone remembered
A Love from her past
So warm and so tender

The day is passing
The Sun's going down
A dashing young man arrives at the door
He crosses the threshold
And looks round the store
He eyes a bouquet…the best in the store
"These are for you"
Their eyes quickly meet
It's love at first sight
His Soul mate he's found
They'll go dancing tonight

After all…this is Paris
The city of lights
Where anything can happen
And nothing is plain
This is the magic of Patrick Allain

Wedding Dress

All so beautiful, unique
Bearing their imprints on our Soul
Silk, organza, crepe, chiffon
All in white
Each an attempt to lure the bride to be
Flowing, fluffy, the veil, the train
Sequined, satin buttons, appliqués of imported lace
Straps, strapless, low cut or high
Sleeves, and without

All tell their tale…about the bride to be
Who will bring life to these garments

To the farmer's daughter who works the land
They all seem a fantasy
A life she doesn't know

For the corporate lawyer
Frills won't make it to the show

The fashion Queen…a chameleon you see
Always discovering anew
Charting a course known only to a few
Her choices expansive
Her taste a delight
The fairest she'll choose
To adorn her tonight

Yet all will join in with the words

"I Do"

May Love and trust carry them through
For the heart knows not words
Yet feelings abound

And Love is a treasure
That's waiting to be found

Only Time Will Tell

Soccer Mom, that's what they call her
She sits on the bench
Alongside others
Camaraderie with the other moms
She laughs… they talk
But of what matters?
Their daughters…the great shot on goal
The tournament coming up
Who is this woman?

Beneath the din of the chatter
Lost in thought
Mind playing its ever-present games on her
Thoughts long ago repressed
Pushed into the subconscious
Always searching to emerge again
And with them… the pain

Always seeking fulfillment through the lives of others

A promising career
First put on hold
Then buried amid the assumed roles of devoted spouse
And dedicated mother

Hobbies long ago abandoned
Relinquished in her role as Super Mom

Soon, the last will be off
Enabled and empowered by this loving mother
Given a framework bathed in Love and guidance

Who will this child become?
Will she follow in her mother's steps?
Has this woman disguised her pain so well?

Only time will tell

Confounded Confabulations

Confounded confabulations
Of a mind adrift in wonder

Spirit courses through my veins
Scintillating my cells

Its mythical, magical and majestic power
Repairing and restoring
The fabric of the microcosm
Using an ethereal thread and needle
As it travels a tortuous path
Mending the imbalances
Of my Chakra centers

As above so below
Hermes Trismegistus
Brought here to aid us
To help define the structure
And nature of the Cosmos

The questions are myriad
The answers simple

A pure Love
Courses smoothly
Through our energy field

Obstacles such as selfishness and greed
Serve only to thwart us
Creating roadblocks
On our energy highway

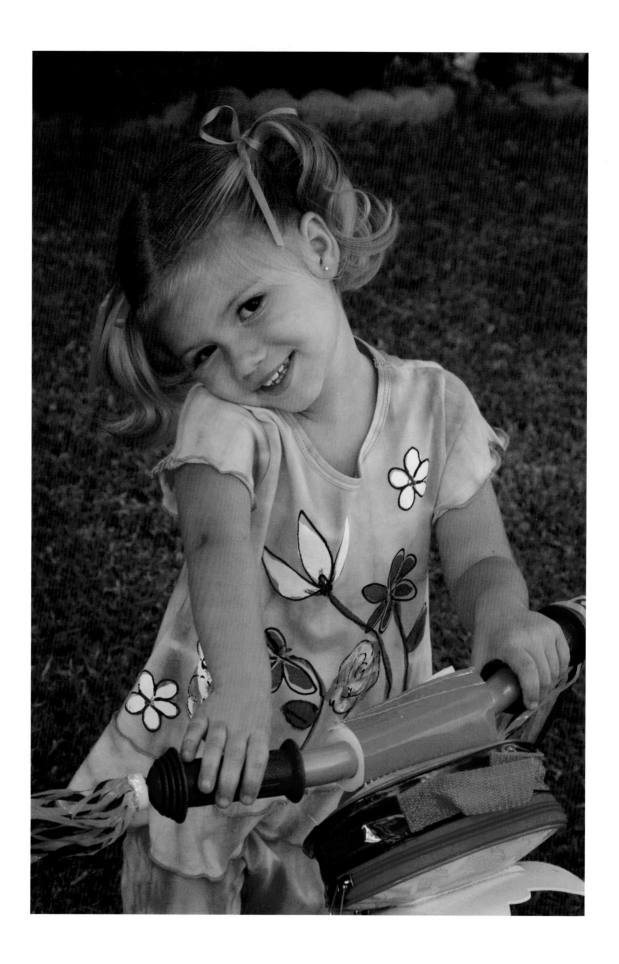

The New Bicycle

Bursting with Joy
She mounts her new bicycle
Pink and blue streamers
Extend from the white rubber grips
At the end of the shining handlebars

With unbridled excitement
She presses down hard on the pedals
The wheels begin to turn

She giggles with glee
Smiling at the neighbors
As she moves quickly past the nearby houses
Her youthful energy exuberant
Spilling over with an abundance
Of Vitality and Joy

Turning back to see her parents approving eyes
She smiles…loses her focus…
The bicycle tumbling to the ground
A scrape of her knee…a trickle of blood
A moment of hesitation
Looking back again
Awaiting her parent's cues

How will they respond?

How would you?

The Glue of Love

Purity of heart
Unity of purpose
And selfless devotion
Are but three of the ingredients
To reach that beautiful place
Of spiritual connection

A Quantum leap to the Cosmos
The keys of Enoch residing within
The Unity of all that is

A message, a prayer
For the brothers and sisters of mankind
To go forth with Love
To seek only Beauty in their brethren
And shed the clothing of greed, fear, and jealousy

Seek to be One rather than Other
Each word and thought serving only
To anchor us together
In the field of Loving Intention
And dissolve the mortar that
Separates us from ourselves

May the glue of Love bind us as One
To remind us of our purpose here

The Edge of Darkness

Sitting on the edge of darkness
A shroud of gloom swoons over me
Distancing me from my Soul's purpose

Inner conflict
Needs, desires, Ego driven goals
Struggling aimlessly to fulfill
Their short-lived hunger for satisfaction
Alternating with
The lofty ambitious drive of selfless devotion
And Unity of purpose with the field of Intention

The recognition of the illusion of Self
Bound to our bodies
The fear of letting go
Of divesting oneself of My, Mine
Possessions!
Their false premise of security through attachment

And yet
A peek at the glimmer of Joy and Beauty
That one can know
In even a fleeting moment of transcendence
Can offer us hope
And inspire us
To make that quantum leap

Make it your purpose to know that both are necessary
For the body is the temple of the Soul
And our Earthly garments permit
The co-creation of Spirit with Source

The Chanteuse

The Chanteuse stands before her audience
They've come to hear this nightingale sing
The timbre of her voice
A presence so rare
Her songs a tonic
For Lovers to share

She sings of times when choices were few
Of pristine Love
With innocence viewed
No what ifs, no demands, no controls
Just the pure pleasure of shared presence

The dashing young couple
The table close by
Enamored with each other
Their glasses click, the champagne savored
These moments, once only dreams
Now the vision of Love complete

Their energy is felt by others nearby
The smile of the singer
Her nod of approval
The highs and the lows, she's seen them all
The joy when they're up
The pain when they fall
She wills her outpouring of Love to sustain them
Her power is limited
The choices are theirs
To rise above their differences
Their Power to share

Trees

Shafts of light twirl their way
Through the tall stand of trees
The arms of nature
Heavy with the morning dew
Leaves drooping after their long eve of sleep
They've dreamed of playgrounds
Man could not conceive of

Slowly, steadily
With the aid of wind and light
Their burden lifted
The lightness of their Being reestablished

The leaves, the stems, the branches
Once again sigh and stretch
And lift their arms to meet a new day

A day for children to play
In the shadows of their outstretched limbs
Lovers to walk hand in hand under their canopy
Birds to perch in the bosom of their embrace
And even oxygen produced
By each unique leaf
For the daily sustenance
Of the human Souls
Who've journeyed with them
To this planetary domain

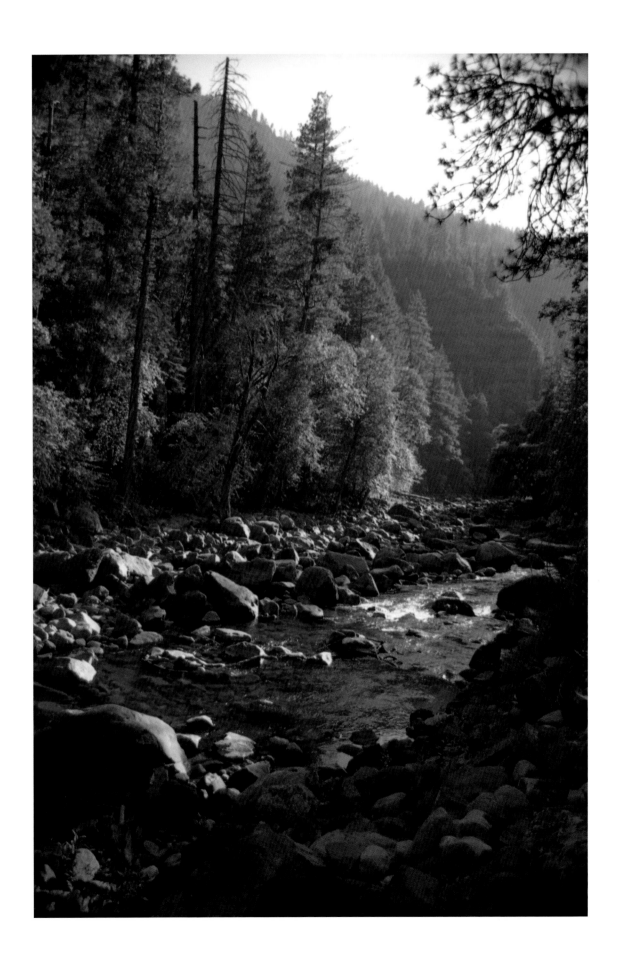

Life's Reflections

He stands in the river
Casting his line, rhythmically, repeatedly
The humming sound of the line
Resonating with the rush of the water
Swirling past his feet

The moments pass
Been fishing here for a long time
Seems like eternity

Trout swimming close by
Steadfast, determined, journeying upstream
Their annual ritual of survival
They move unconsciously
The ages dictating their task
Yet divinely positioned in their place in the Universe

He reaches deep inside a pocket
A picture of Junior
Oh how handsome
Proud face
Broad smile filled with anticipation and excitement

He dwells on his son's countenance
A life cut short

All the things that could have been

First Date

Leaning close into the mirror
With finely tuned fingers
In a highly orchestrated fashion
He squeezes another pimple

An ensuing frown gives full measure
To his insecurity
Girls can quickly apply cover up makeup
But not he

Will she notice my skin?
Maybe I'm too sensitive, too aware
If she really likes me
She may not even notice my Earthly flaws
My not so perfect body

She seems so charming, so homespun
That cute, little impish smile

Well, you know, she did say yes
When I asked her out

We certainly are so much more than our bodies
I'll just try to forget about that little blemish for a while

Perhaps she has a few things about her
That could use some improvement
I really can't think of any right now
But then again
I hardly know her

Funny thing
How so often we first feel attraction
On the physical level
And yet, after a while
Conversation and interaction
Serve to lift the veil of the physical
To reveal the jewels
Waiting to be discovered
Beneath surface appearances

Baring our Souls
Revealing our bright sides is easy enough
It's the dark side
That always offers the greatest challenge
Using creative ways to keep it concealed
As best we can

Like a jeweler, who,
When cutting a flawed diamond
Seeks to bring out the best appearance
He can fashion from the imperfect stone

We all possess a shadow side
Yet…it pains us to accept this
In a world always seeking
Air brushed perfection
Yet…it is because and in spite of
Our imperfections
That we are each
Unique and extraordinary Beings

We can make the choice to go deep inside
And face our furies
Look at them, and learn from them
And accept ourselves
Even in our humanness

Look back in the mirror once again
And find the Angel inside
So capable of Loving
And deserving to be loved

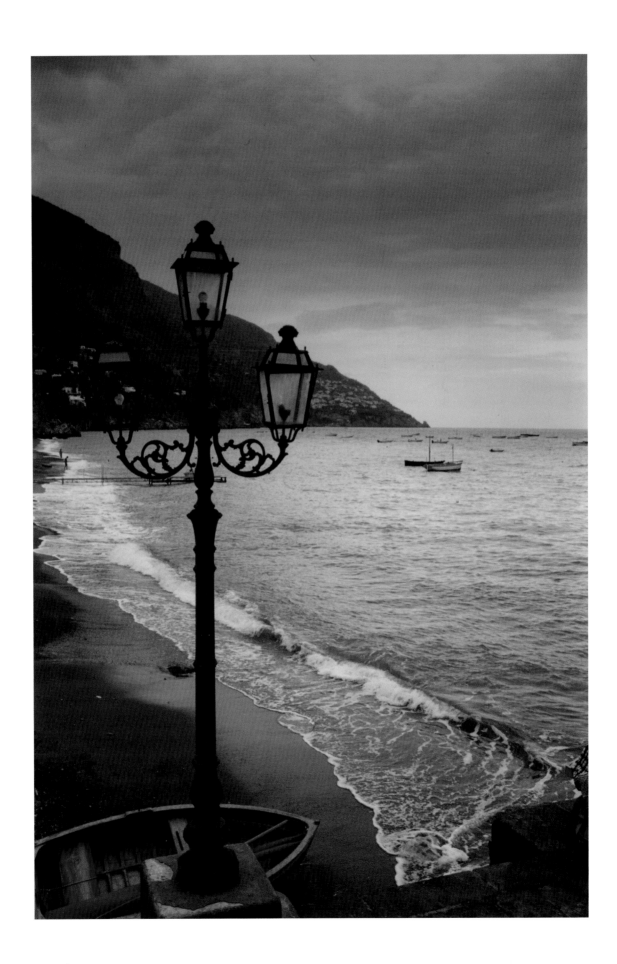

A Life Well Lived

Stooped over, leaning on his cane
Ambling slowly, deliberately
Along the cobblestone paths of the ancient city

Wildflowers peak through the cracks of the fortress
Walls that stand in testimony
To the passing of old and young alike
Through their portals over the centuries

Fond memories of his youth
Bring with them a broad smile
The daily trips on his venerable old craft
To haul the nets and sell his catch each day
The work was hard
Sore, fissured hands…calloused
From years of pulling the ropes
His weathered face…aged prematurely
By his days at sea

He would write of the days of fury
Or the times of stillness
Yet…who would listen?
Who would understand?

Only a few small ships like his remain,
The old yielding to
Powerful new craft with automated equipment
Insulating man from his beloved sea

He reaches the wharf at last
From his bench he looks out
The waves breaking
Rhythmically, ceaselessly

His eyes close, a restful presence
His thoughts drift
A voice
Once so familiar, appears close by
It's Dad
Come Son
It's your time

The Artist

Her fingers move nimbly as she works the metal
Her Soul guiding them in a divine fashion
Another piece complete

The small gemstones sparkle in their new settings
Sharing a wondrous bond
With the burnished metal embracing them
The Artist weaves her energy
In each lustrous manifestation
An infusion of Soul and Spirit
In every creation

A vision arrives with the final touches of each piece
In her all encompassing Love
She will share the Joy and Serenity
Of those who will adorn themselves
With these gifts from the Universe

The elegant self-confident fashion editor
Gazing at her bracelet
As she enters the boardroom

The radiant bride to be
Looking in the mirror with a dreamy excitement
As she tries on this exquisite necklace

The loving wife who will receive this special ring
From her devoted husband for a special anniversary

All these Souls will be touched
By that small piece of Divinity
Residing in each creation

In their Joyful
As well as in their troubled times
They will feel
Their eternal bond to Source

Inspiration

To be filled with Spirit
Sounds so simple…yet so elusive
You know…life has a way of discharging our batteries
And why is that?
We arrive here fresh out of the starting gate
Our caretakers…in their efforts to civilize us
Break us down to mediocrity
Conform us…guide us…limit us

Our power, slowly, steadily depleted
Never complete…never good enough
Always wanting for something

In their limited vision
They seek only to shape us to their mold
Telling us what we can and cannot say
And invalidate or deny our feelings

Forgive them…for they know no better

Yet…when we grow
The responsibilities become our own

Stripped of our power
It becomes easy to let others guide us

Anonymity acts as a blanket of security

The comfort of familiarity
The fear of uncertainty thwarts us

Take in a big breath of Self Love
Cast away the Self pity

There are no victims here
There is only one gear…forward

Feel your power grow

Lifted By an Angel

Dimpled cap, weathered face,
Days old whiskers,
Tattered, torn sleeves of the faded black coat
Loosely covering his gaunt figure

A child scurries by
His eyes follow her path

Dreams of dashed hopes
A fearful, troubled existence
Each day mirroring the one before
Living in a cloud of confusion and uncertainty

A beautiful scent and invisible presence
Pass over him like a gentle breeze
Pulling him upward from his pain

He gazes upward toward the Heavens
His spirit rekindled
The veil of doubt drifts away

And alas, a smile appears

The Illusion of Duality

The Light that gives
The Love that lives
Inside you all is me
For I am that
And you are that
The Earth, the Sun, a tree

The threads that bind us
Our families beside us
Remind us who we are

There is no me
There is no you
Only Love is real

For when we seek to be complete
Our Earthly sojourners
Will bear the fruit
Of the unconflicted Soul
Who's learned that our presence here
Will serve to make us whole

For I is not Me
But the whole of All

It is only then
Our eyes will see
The Illusion of Duality

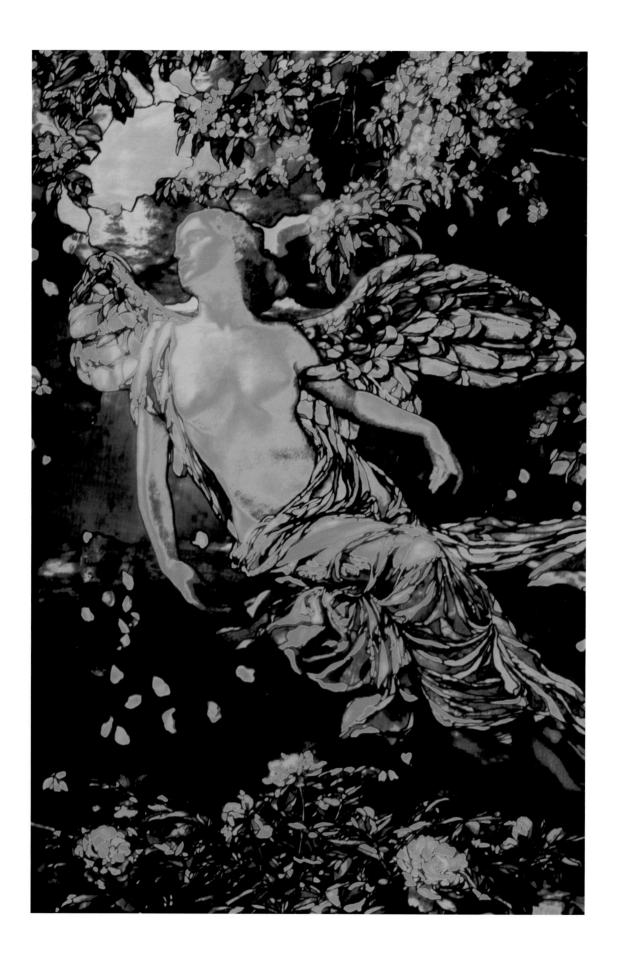

Celestial Angel

Floating in the ether
Above the world beneath her
A vision of beauty
Of God's grace she's born
To release the pain
Of the weak and forlorn

She'll aid those in need
With comfort and speed
And lead you from sorrow
To a better tomorrow

Your grief she will feel
Your pain she will heal

The Joy you will know
In her warmth all aglow

Celestial Angel
The song of the spheres
Forever present
Forever near
For those in grief
Relief she shall bring
Hear the voice of your Angel
Your Spirit will sing

Missing Him

She slowly rises up from her garden
Beads of sweat on her brow
Her pores issue forth moisture
To cleanse her from her deep rooted sorrows
She turns…for a fleeting moment
His presence seemingly there
And then…gone so quickly

Memories rush past
Fleeting glimpses of their brief time together
What is brief?
An hour…a day…a multitude of years?
Time seems to pass like the frames of a film
And yet
A moment of Joy can seem so timeless

The cry of your baby…now so grown
Your new puppy…. now hardly able to move from her
Favorite place in the corner

Thoughts of him …again
His smile, a tender caress
A big hug for his granddaughter
Her contagious laughter, as he tickled her
Her youthful innocence… proclaiming
"Stop Grandpa"
Yet she really wanted another giggle
Another hug

Don't we really all want more?
That cruel desire, Wanting…
Our well of need is so deep, so broad
Its thirst, at times unquenchable
A sheepish grin
Reflections of a special shared moment
Thoughts like these to give her solace
These will strengthen her
Help her heal from the pain of despair
Her Angels will guide her through the darkness

Meeting the Sun

The sand crabs scurry along the water's edge
Squealing in delight
As they burrow and emerge
In their tireless self indulgence
Feeling only the pleasure
Of each moment of their being
Each morning she rises early
And takes the short walk from the beach house
To meet the sun
Heralding the onset of a new day
Her daily ritual following
Her long sleepless nights

She can still hear his voice
The faint scent of his cologne
The gentle caress of his fingers
His presence…almost palpable…close by

This home…once filled with so much life
The children…their vibrant energy…youthful spirit
Now grown up…residing on distant shores
Now…the creaking of the floorboards
The only voice to share her loneliness

Why did he leave?
I thought my Love could sustain him
Gone…in a blink
Such pain,
Such despair

Wallowing deep in a valley of self pity
She rises from her place in the sand
Her slow small steps
Making their imprints
Of her time here

In the distance…a man…walking her way
His presence draws near
Their eyes meet

Hi! I'm Jim…your new neighbor

Grandmother

The doily rests on the table close by
Delicate lace fashioned years long passed
Flowers on porcelain on a lamp dimly lit

Shadows on walls cast by her frame
As she rises slowly
From the chair where she sits

A peak out the window
Her garden so close
The children at play
Their voices and laughter
Bring joy to her day

Snippets of time
Fragments of memories
A parade of emotions
Pieces of dreams

Each day a blessing
A gift of life

The screen squeaks
As she walks out the door
Her garden awaits her
The flowers…tongues wagging
For their daily ablution
Her watering can provides the solution

The Joy of the Mother
To Nature she's bound

Her days here are numbered
She'll leave unencumbered

Her body will merge
With the ground she holds dear
Her Love and her Spirit
Will always be near

Just a Glimpse

The deep crimson petals of the Bougainvillea
Soften the edges of white washed eminences
Framing the frail dowager as she advances slowly
Along the sea wall

The humbled aspirations of her time worn years
Drift with her thoughts like the shimmering
Light dancing on the nearby waves

A passing fragrance, the ancient stones
Traveled so often by those who've been here before her

Each day these steps are taken
They seem so familiar, and yet,
Today, appears a new spring flower,
Springing forth from between the cracks
A joyous smile of the Mother

Eyes drift, a furrowed brow,
Thoughts of a grandchild's visit
A sweet and comforting reminder
Of her childhood days

Running down the path,
Past the Lilacs and the Lilies,
The Rose garden,
To the Tea house
At grandmother's lakeside cottage

It can't be…wasn't it just yesterday?

Or was it?

God's Playground

Hope rises up from the depths of despair
As the dawn awakens Mother Earth
From her deep slumber

The wave of Spirit journeys across the sand
Climbing, descending the dunes
Moving in flow
With the whistle of the wind
In rhythm
With the gentle breaths of the Earth Mother

You can feel God's presence
As the sands shift
With the playful movements
Of His shovel
Moving in tune
With the music of the celestial spheres

Co-creating with each of us on a grand scale
His fire is carried in his outstretched arms
To keep us warm
And deliver Light to see ourselves

The morning light rises
From between the peaks
God's reflection of transcendent beauty
Wrapping us in Love's embrace

No one or thing is excluded
The Light has no boundaries
Each of us an emanation of Spirit
Guided here to this earthly presence
For a specific role in God's great theater
Each on a special mission
To join together on the path to Love

Crossing the Plain

The Wildebeest strides gallantly
Just one small member of a massive herd
Thundering across the plain
The path is not his to carve
But merely to follow

His identity is not singular unto himself
Yet is mirrored all around him
In the thousands of his brethren

His Soul seeks not individual concerns
Yielding to the collective Soul of the herd

Elegantly, valiantly
They journey forth together harmoniously
In their search for food and survival

For their strength is in their numbers
Each in deference to a higher purpose
Long ago having learned the Power that is theirs

And yet…there are those who will stray from the herd
Moving to a different vibration
Somehow…unable to keep up
With the vortex of the energy
Of the group

Many are sacrificed in nature's daily ritual
Sustenance for those higher on the food chain

Fear not for them
And feel not sorrow for their loss

A greater wisdom than we can perceive
Orchestrates these Divine movements

For Life and Death are only illusions
And All that is
Will always be

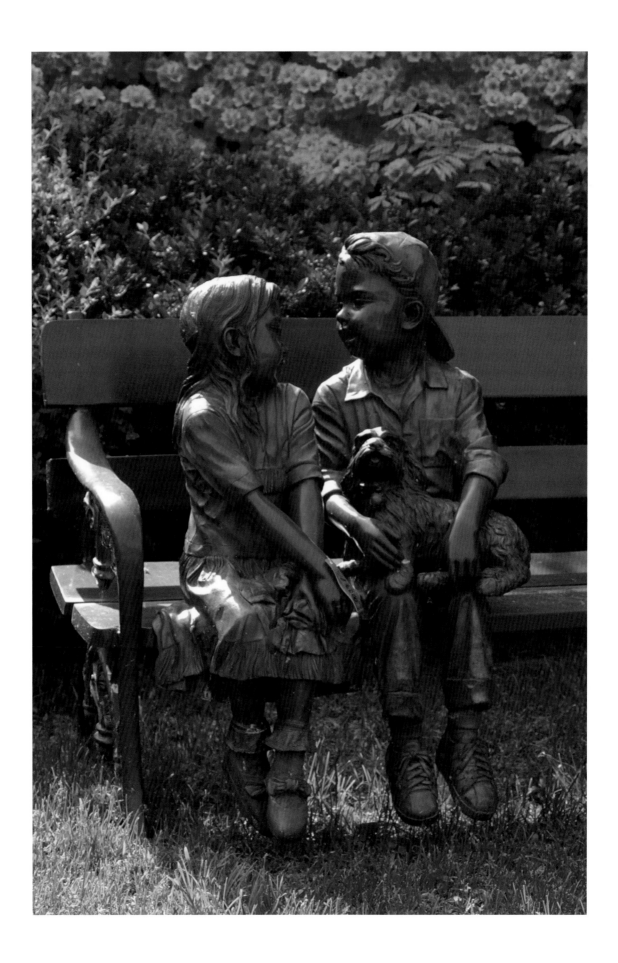

Puppy Love

On a park bench they sit
Entranced so they seem
The gaze in their eyes
Their faces do beam

Puppy on his lap
Her arms folded, body erect
A carefree existence
A smile of the ages
Their Love is as fresh
As the scent of cedar in a virgin forest

Their Joy is their presence
They speak of their lives
The day at the lake
The cookies, the ice cream
The sundaes they'll make

Go back in your heart
Remember those days
Dwell not on your pain
Experience and Love
Bring with them their strain

The quilt of your life
So rich and so textured
The layers enmeshed
With your Joy and your sorrows
Remembrances of your yesterdays
And the promise of tomorrows

Yet live in your present
A day filled with wonder

Recapture the essence of this boy and this girl
Dance and sing
And spin in a whirl

For life is as changing
As the waves on the shore
You never quite know
What life has in store

Let your beauty shine through
Live each day anew
The bounty of Life
Will be there for you

The Chemistry of Love

Search…click…a gallery of photos appears
What gift will the Universe bring today?
He scrolls down the screen
Ah…there she is
Her eyes, her smile
Symbols of her radiant energy
Her beauty admired by those
Whose energy share her field of vibration
Another click…her portrait appears
Words can offer only a small glimpse
Of this time honored Soul
Who has visited planet Earth
In various visages, in different costumes
Through the eons of time
This precious Soul exploring…experiencing
Always learning…always giving
Her expansive heart…sharing, creating, loving
Mingling with her classmates on this earthly realm
Each Soul a mere fragment of Source
And yet complete
A microcosm of the macrocosm
Each always connected to
The wellspring of Infinite potential

And yet, we arrive here having forgotten who we are
Spiritual beings in communion with Source
Cut off, we spend our lives in search for connection
We seek that special person to help us feel complete

In that search you must give thought
The prejudices, biases that we harbor
Are merely mirrors of our own imperfections
Limiting us in our field of attraction

In relationship choose not to control
Or strip another of their power
Fill yourself with love, self- respect, and self- nurturance
For the Power of Love comes from within
The Love you attract is a reflection of the Love you send forth

Young Lovers

The surf laps gently against the soft white sand
Embracing the shore
With the countless kisses of the Universe
The gulls meander, seemingly aimless in their movements
Searching for the morsels of food left behind
By the day's beachgoers

The Sun almost retired from another day
Of bringing light and warmth
To the Mother
The daily exchange of Love from Source

The suntanned, glistening, well toned bodies
Of the young couple
Observed with admiration
And sometimes, a little envy
As they stroll past

Engaged in their own rapture
They see only each other's eyes
Blissfully walking
The timeless dance of new found Love
Hands locked
Moving as one
Their steps synchronous
With the beat of the waves
Caressing their feet

At that moment
He stops, turns
With great purpose and feeling
No longer hesitant
No longer fearful
To express his deepest longings
No longer in doubt
He whispers in her ear

"I Love You"

The Quest

A light beam sizzles across the starburst skies
Upon it is me
Giggling with giddiness as I crisscross the Galaxy
The voyage gets better with each traverse
My excitement can hardly be contained

The quest for knowledge
A lifelong rite of passage

Arriving at last
At time warped speed
To an illuminated state of Grace
Unfettered from the encumbrances of physical form
Consciousness expands
Boundaries once extant
Dissolve in the Joy
Of the vibrational force field
Of Love and Light

May the Light of Love
Embrace your Soul
And Guide You
In Your Travels

About the Author

Dr. Robert Sasson has bridged the gap of bringing modern medicine to rural, historic Bucks County by opening the first pediatric practice in Newtown, PA. Through the years his practice has grown, and is now a part of The Children's Hospital of Philadelphia. For over thirty years Robert has provided medical care to the families he serves, attending to their physical as well as emotional needs. Dedicated to improving the lives of others, he has also founded a nonprofit organization called ENRICH Bucks County (Educational Network and Resource of Information for Community Health). This collaborative effort utilizes the talents of local professionals of various disciplines with the assistance and support of United Way Bucks County.

Along with a great love and lifelong career caring for children, Robert is also passionate about poetry and photography. He is blessed with an unquenchable thirst for life experience and learning. Inspired by the visions of the great landscape painters of the past, he makes use of the digital toolbox to create modern day 'paintings' to remind us of the beauty of nature and grace in our lives. Through his imagery and words he yearns to bring feelings of joy, peace and love to his readers.

Robert Sasson lives in Newtown, Pennsylvania. His three wonderful sons, Aaron, Joe, and Dave, and three beautiful granddaughters have been inspirational in his writings. It brings Robert great joy to share his journey through life in his first published book, *Visions of Thought*.